PREFACE

Over the many years that I have been photographing different personalities, there have been certain individuals that seem to have been blessed with a God given gift to be a star. No matter who they meet, they're able to inspire an audience of one, or captivate millions to listen to their music or to see them perform. Donna Summer was one of those divinely gifted artists. Through a series of fateful events, I was chosen to capture her earthly spirit during the years and albums that were pivotal in solidifying her superstar status.

For years I have been asked by Donna Summer fans to compile a collective book of some of my special images that I captured of her over a span of four decades. Through these years Donna and I formed a deep respect and friendship beyond our photo sessions. We both were very spiritually driven, creative souls. So, it is with great reverence that I have compiled the pages of this book. I felt a special presence guiding me through the process. These are my personal memories and recollections. I hope you all enjoy them as much as I do

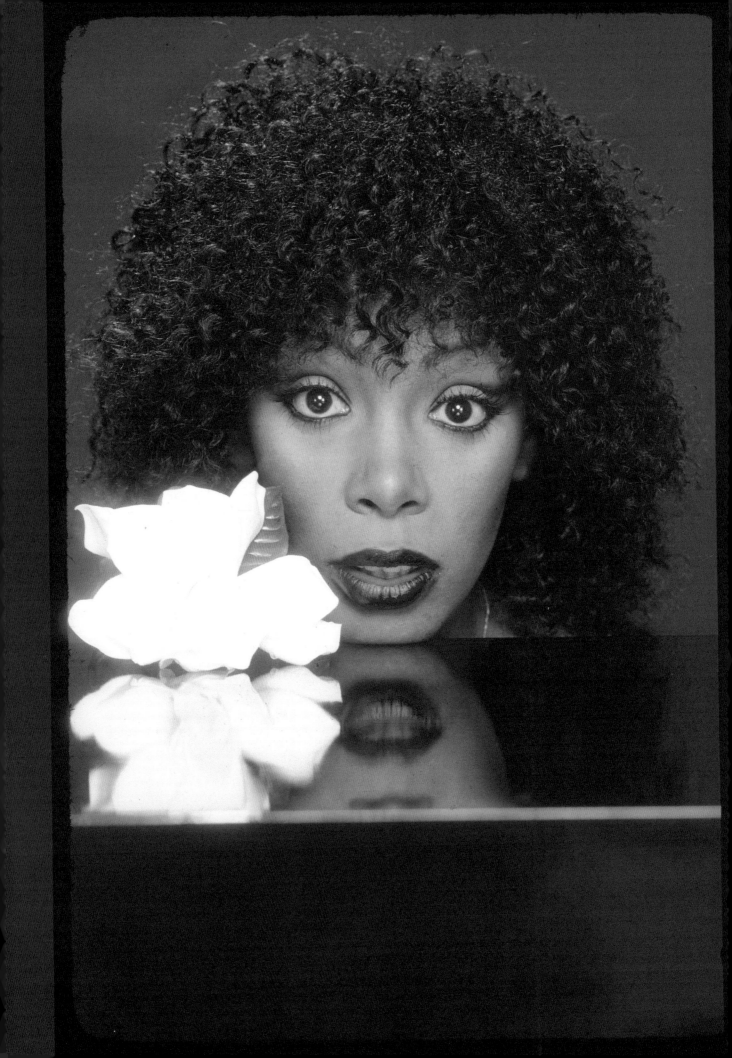

MEETING DONNA

In the Spring of 1979, I had a run of important photo sessions that had me booked back-to-back. At the time I had a studio on Beverly Blvd., adjacent to Beverly Hills. In my studio, I had my own print department which kept two girls very busy, and I had a full-time assistant to help me build sets. There was no Photoshop. I personally would create & build sets for my photo shoots.

It was another busy day for me. I had just finished a session on Suzanne Somers, and I was in the process of editing her best shots for her publicity. During these hectic days in order to stay centered I practiced meditation techniques that were popular at the time. I also attended a local church with many of my clients which gave me a strong spiritual grounding.

The phone rang, and my assistant came in to ask me to take the call from a perspective client. She said the caller was insistent on speaking to me personally. I was curious as to the urgency of this unknown caller, so I grabbed the phone. The caller introduced herself as Joyce Bogart.

Left: This was the first photo I ever took of Donna with a gardenia I gave her when she came into my studio for her test session.

She stated that she and her husband Neil were managing a new talent for their company Casablanca Records and that they needed to book a photo session with me.

She was vague only sharing with me that her new talent was in town from Europe, and that she had been in the cast of the musical "Hair." She said her client had recently signed with Casablanca, and they needed an image for her upcoming album.　I assumed a portrait session of their client was all they wanted.　However, Mrs. Bogart explained that they wanted their client to play a hooker on Sunset strip.

As I was involved with a church at this time, I told Joyce I was not interested in the job.　She exclaimed that I would be foolish to not accept the request and begged me to reconsider!　I told her that I would consult with my staff to see how they felt and get back to her.　My staff at the time was all between 25 -30 years of age, and they all urged me to accept. Bolstered by their enthusiasm I thankfully did.

Performers often like to try out a photographer with a test session to make sure there is synchronicity between the two parties.　A week later I received a call from their talent directly to do just that.　This was the first time I spoke with her, and heard her name ... Donna Summer!

On the day of the test session my staff and I were ready and waiting. However, shortly before it was to begin, we received a call that the session would unfortunately need to be canceled.　Of course, we were all

quite disappointed. We began to relax and eat the food I had ordered. A half an hour went by, and there was a knock at my door. To our surprise it was Donna. In order to gain privacy, she told her management that she would not be coming in. It was a clever trick on her part that worked as she had hoped. That day, Donna brought in only one red jersey dress and did her own hair & makeup. She had a technique of applying her makeup that made her skin glow. I did a few simple bare shoulder shots of her in the dress, and a couple headshots of her. Years later one went on to be used for the cover of her "Love To Love You Donna" album. This was the start of our creative journey together!

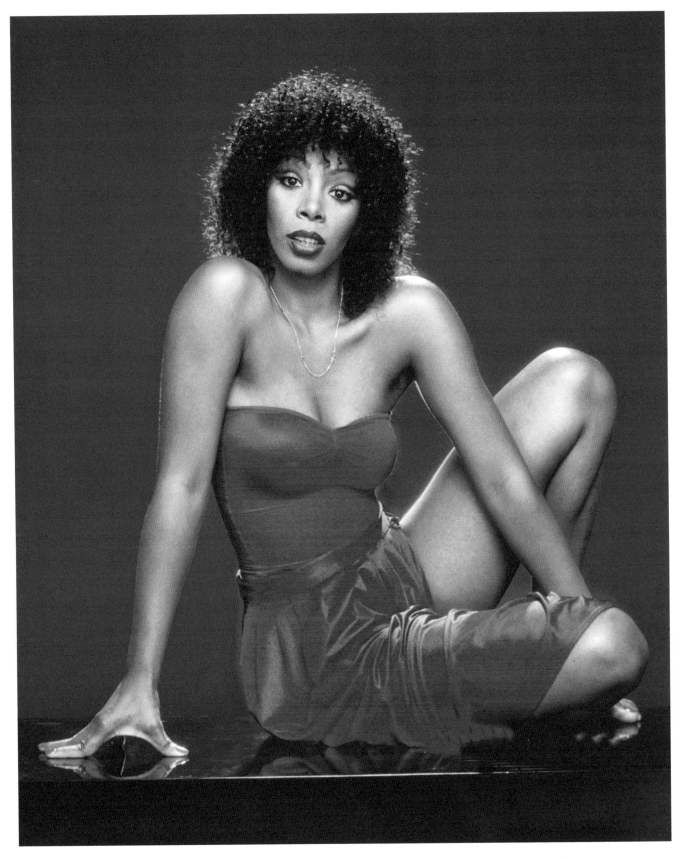

This simple red dress was all Donna wore for her test shoot, proving a beautiful photo does not require an elaborate wardrobe.

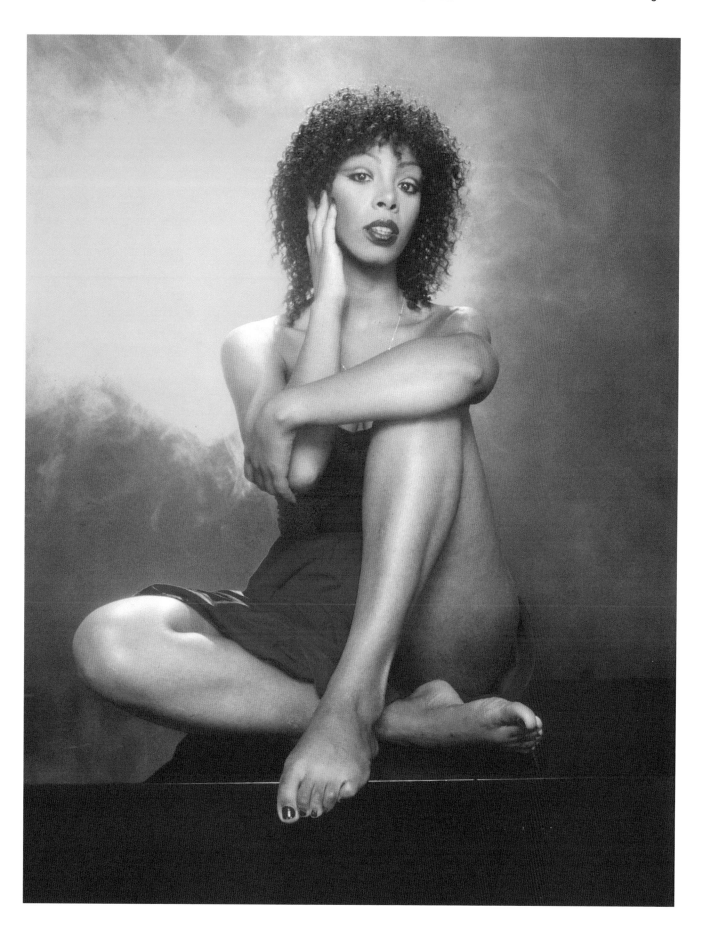

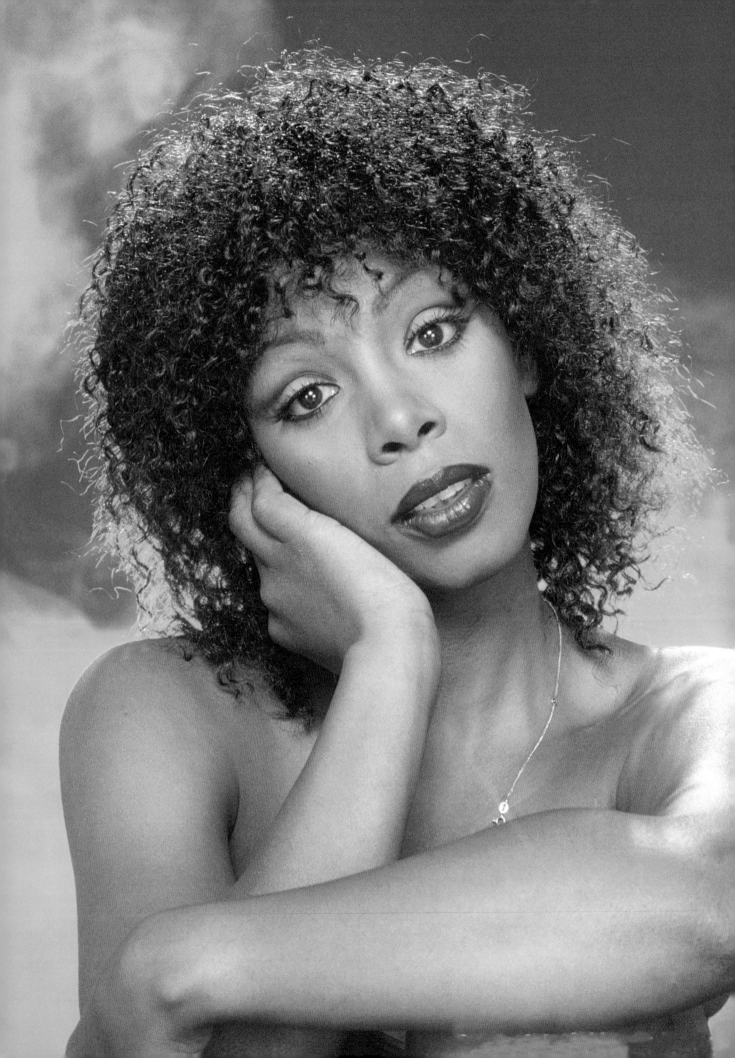

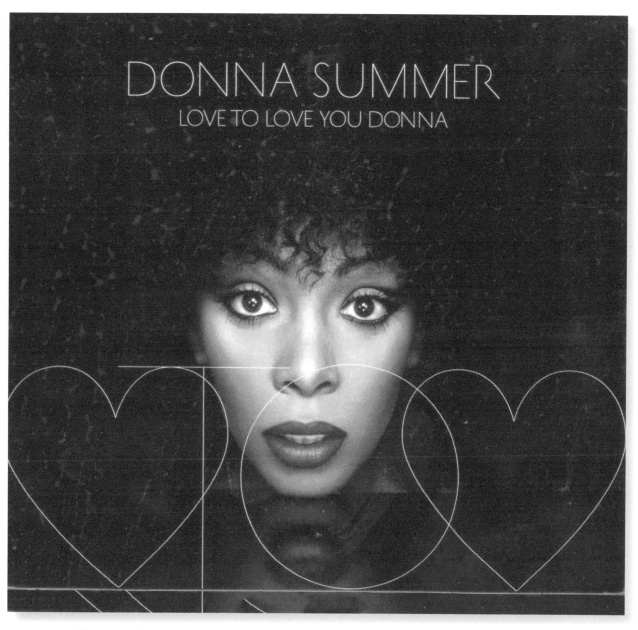

This test shot ended up as the cover for her "Love To Love You Donna" album.

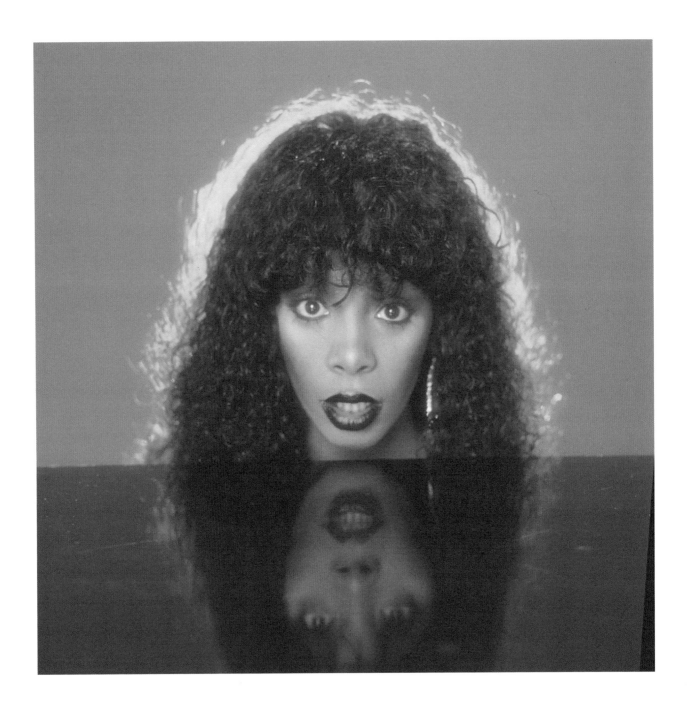

SHOOTING "BAD GIRLS"

After my initial shoot with Donna, only about a week transpired until I received the official request from Casablanca records to book a shoot for the album cover as soon as possible. Of Course, I was elated to hear that Donna was thrilled with our 1st session. But I did not have much time to relax or register this fact, as I now had one of the biggest shoots of my career coming up in a matter of days.

The record company told me they wanted to recreate a street scene by using store fronts, a large streetlight and fire hydrant in my studio. For the album they wished to capture an image that implied a man's perspective as he looked through his car windshield searching for "tricks," aka prostitutes, as they were referred to at the time. In order to accomplish this, they would bring in a real car that had been cut in half so that it could make it through my studio doors. I got off the phone and quickly notified all my top crew that I would need extra help in the coming days to prepare. As it was, with everyone helping, it took two full days to assemble and arrange all the props for this shoot.

The day of the session arrived quickly. In addition to my crew of four, Donna had an entourage of about 10 people with her. As one can imag-

ine when working on a big shoot like this it is important to supply food for everyone. So, my kitchen was stocked, and we were ready to go!

During my sessions I maintain a positive and uplifting vibe. I treat everyone as a star. I find that reminding my clients of their achievements helps me get the best images of them. If my client is a musician, I play their own music or music of choice during my shoot. So, I had several loudspeakers playing Donna's music. The decibel level was high, and the mood was jovial as we began.

The men that came in with Donna performed various roles. Donna's husband Bruce Sudano had a band named "Brooklyn Dreams" that worked with her. Several of the band members had agreed to play different characters in the images I was shooting. The session took on the scene of a stage play as they all changed into different costumes throughout the day with Bruce playing the policeman.

I needed to remain mobile to capture all angles. To do this, I used strobe lights. Using strobes provided my subjects and me with a bit more freedom to move about, as they freeze movement. The streetlight was actually a small strobe light that we encased in the glass on top. Strobes, while very bright in intensity, remain cool in temperature. This was also important because, with so many people on set, I did not want anyone to overheat.

The session lasted for about four or five hours. Donna changed periodically into different outfits and wigs to portray a woman of the evening on Sunset Blvd. As you can see from my photos, Donna remained beautiful throughout. The Bad Girls album went on to become Double Platinum and sell 2 million copies!

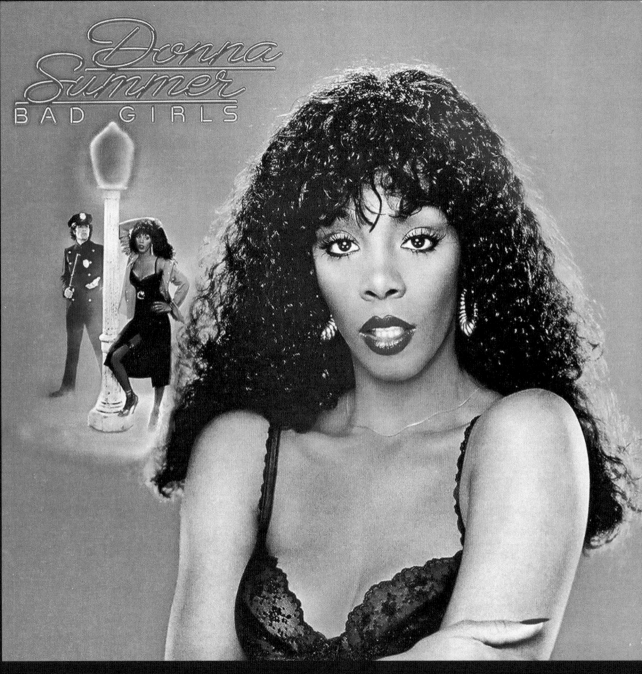

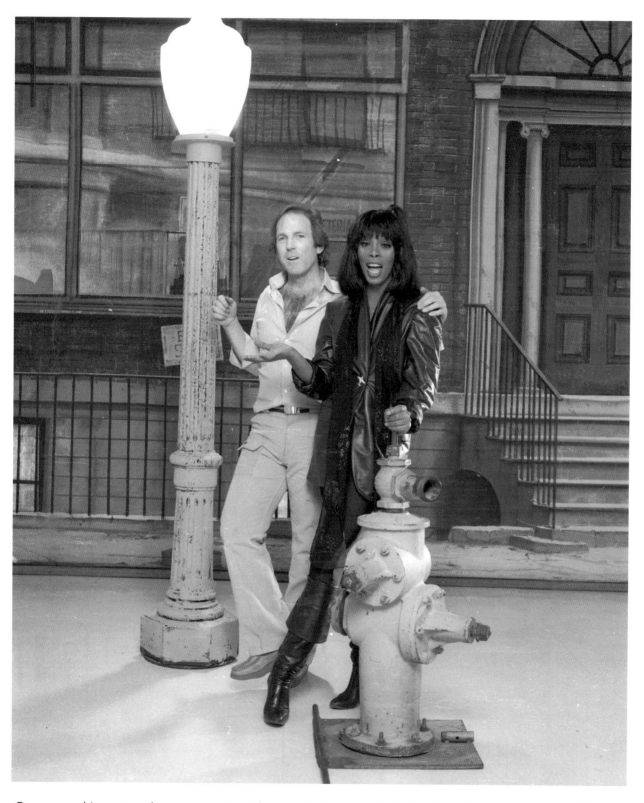

Donna and I captured a moment together on the "Bad Girls" set right before all the action began.

Left: "Bad Girts" Album Cover (Front).

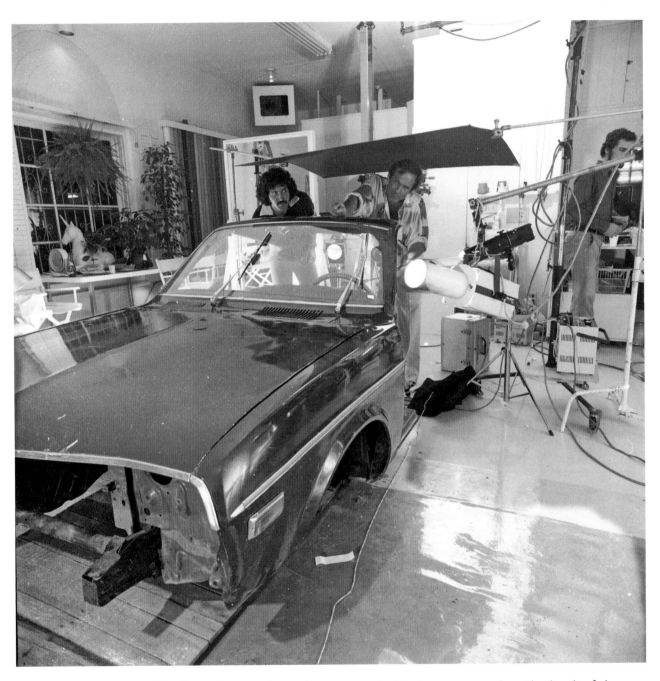

This is the disassembled car that was brought into my studio that was used on the back of the "Bad Girls" album cover. I had to climb into the car, and shoot over the shoulder of a guy to capture Donna through the windshield viewpoint. This was a very complicated shot back then. Today it could be accomplished a lot easier with Photoshop.

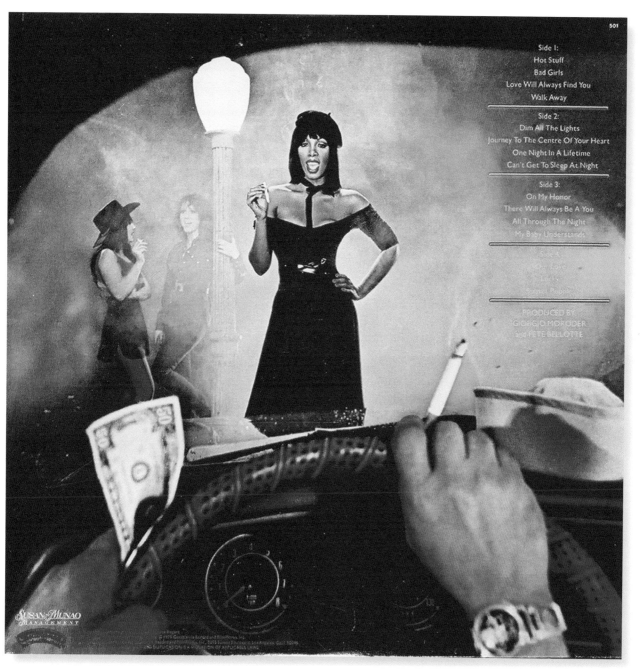

This was the shot I captured using the car that ended up being used on the back of the "Bad Girls" album cover.

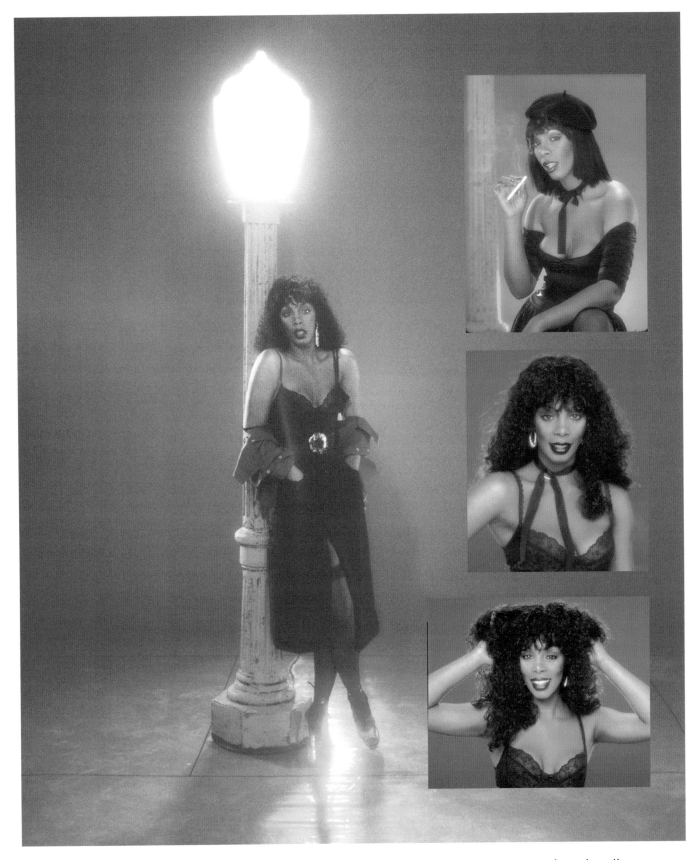

These are various other shots that I captured during the session; some were used on the album.

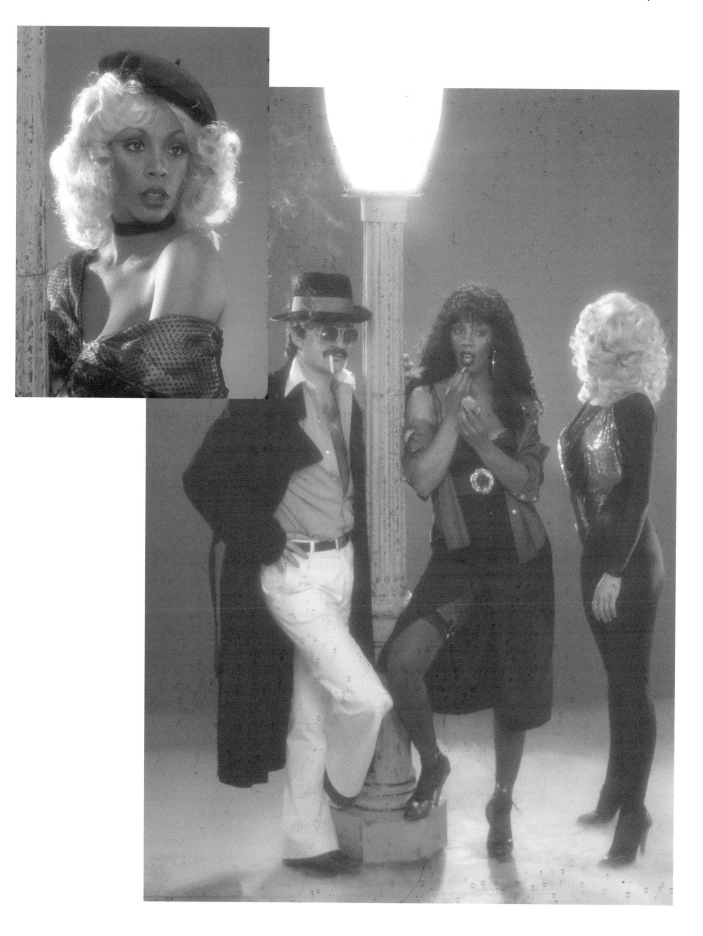

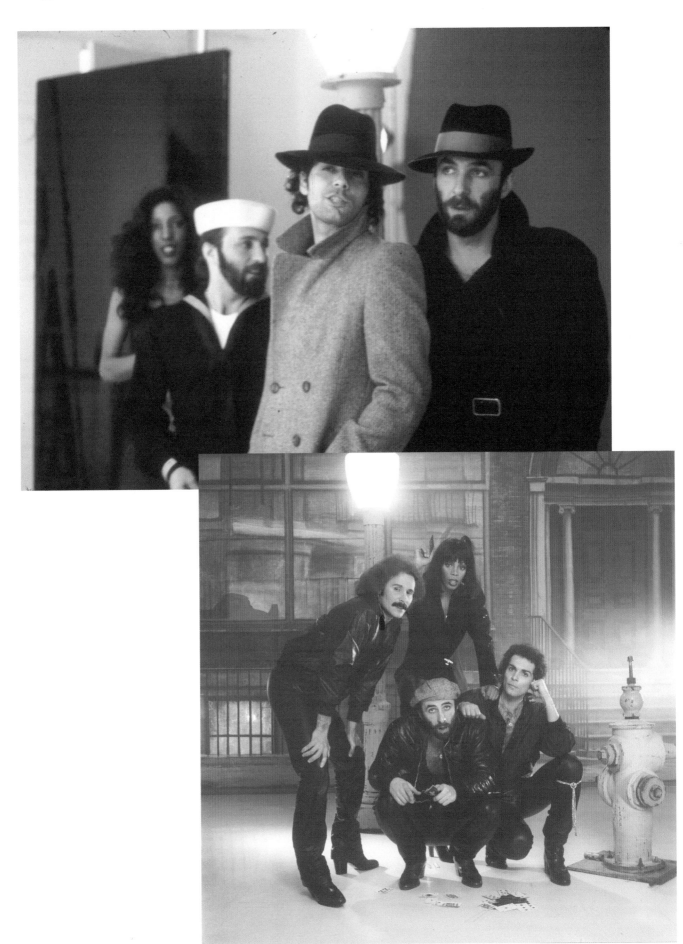

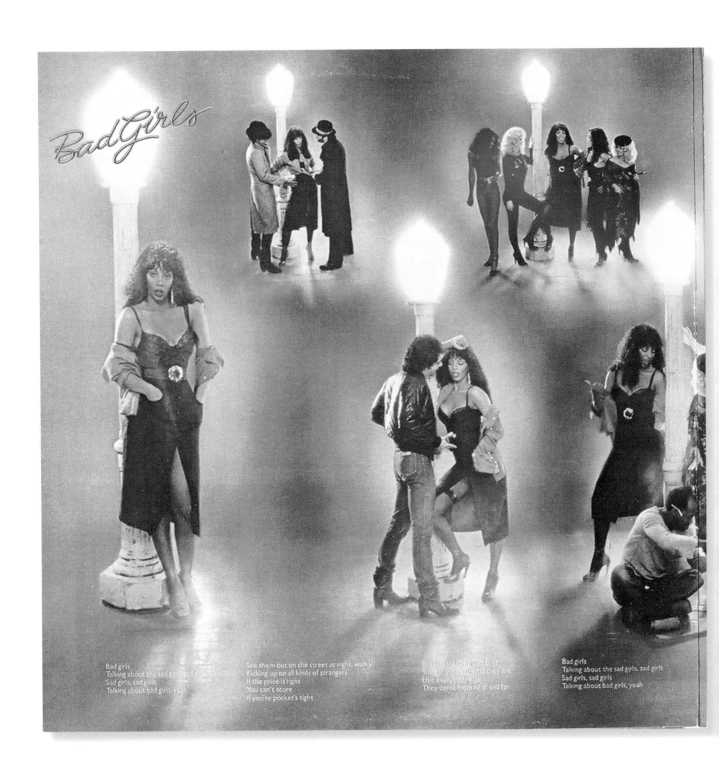

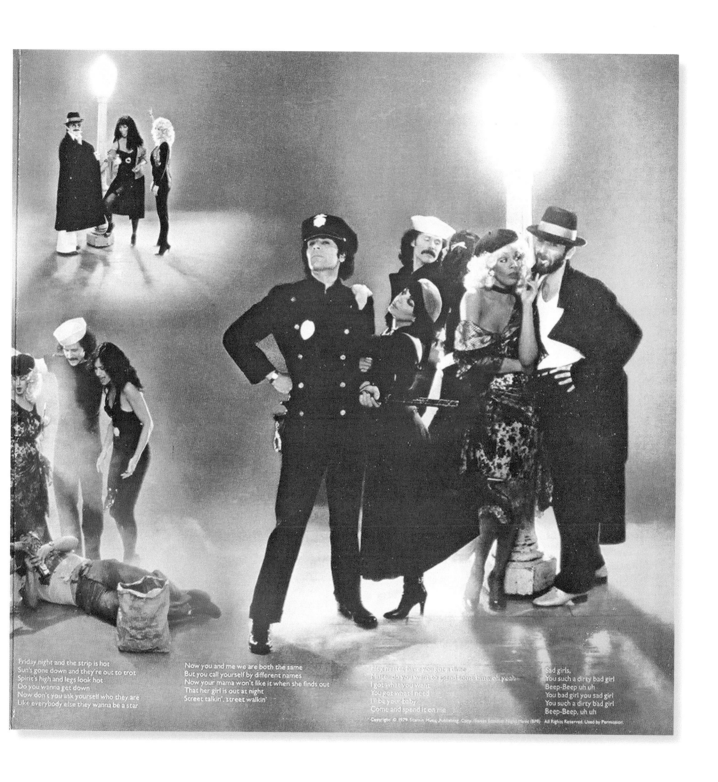

Friday night and the strip is hot
Sun's gone down and they're out to trot
Spirit's high and legs look hot
Do you wanna get down
Now don't you ask yourself who they are
Like everybody else they wanna be a star

Now you and me we are both the same
But you call yourself by different names
Now your mama won't like it when she finds out
That her girl is out at night
Street talkin', street walkin'

Hey mister, have you got a dime
Mister do you want to spend some time, oh yeah
I got what you want
You got what I need
I'll be your baby,
Come and spend it on me

Sad girls,
You such a dirty bad girl
Beep-Beep uh uh
You bad girl you sad girl
You such a dirty bad girl
Beep-Beep, uh uh

IT'S A WRAP

After a full day of shooting, I always try to capture a final group shot to commemorate the day and to serve as a memento for all who helped accomplish it. The group shot from Bad Girls includes hair, makeup, wardrobe, assistants, band members, managers etc. I do not remember everyone's name but, one can appreciate the kinship we all felt after completing such a monumental session. It is much like the way a film-crew feels once a movie is wrapped.

At the end of the day, once I put down my camera, I experience a release. I often liken it to being a creative childbirth for me. I derive a great deal of satisfaction when I am able to produce the images of what began as only a concept or idea in one's mind.

Yet, as the photographer, my job is far from over. In this case, I had an enormous amount of film to be processed. Then, I reviewed all the images before I delivered them to Casablanca. Editing and picking out my favorites is the final act of doing a shoot like this for me. My main objective is always to please my client, who in this case was Donna Summer!

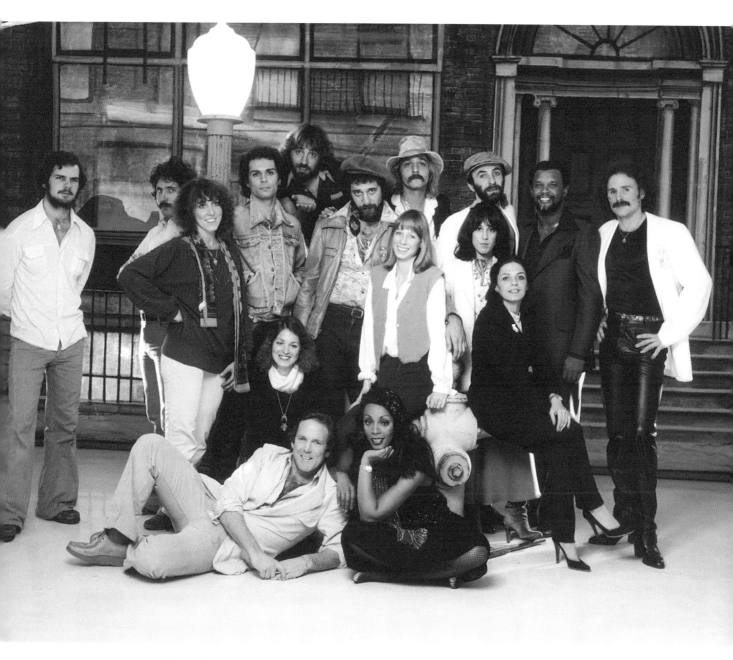

The ending group shot of the "Bad Girls" photo session crew.

CREATING "ON THE RADIO"

1979 was a big year for me. It was only about 6 months later that I was to get another call from Casablanca's art department, requesting my talents again. This time I was provided with even less information ahead of time. They just asked for me and my crew to show up at 11am on a Thursday morning at Universal Studios.

I went into it blindly. But I love a creative challenge. It often propels me to even greater achievements. As my crew and I arrived that morning we could hear loud music booming from two very large concert speakers that Donna had the studio erect on the street. They were playing her new song, soon to be a hit, "On the Radio," to serve as an inspiration for the crew during the shoot.

As I arrived on set there were five or six Classic Cars on either side of the street scene. By this time Donna was well known. She was able to influence Universal to repaint all of the buildings on the lot with bright cheerful colors. One of the buildings was a ornate ice cream shop on which she had them paint "Harry's Ice Cream" on the window using my name as a fun gesture!

My crew of four did not waste any time. We began placing the classic cars in their designated spots and setting up my equipment. I chose a beautiful yellow roadster to be parked in front of the ice cream shop and placed an old jukebox outside the window for the first set.

It was now early afternoon. The heat and smog that day were extreme! Several of my crew took their shirts off and were splashing water on each other to stay cool. There was a fabulous catering truck filled with a wonderful assortment to keep us all going. However, everyone was eagerly awaiting Donna's arrival.

Universal Studios began to get nervous about the music's decibel level. People could hear it from other sound stages and complained. So, they required it be turned down to an almost inaudible level. I too was getting nervous that we were losing light. Shadows were starting to be cast on the buildings.

Donna arrived around 4pm in a casual skirt and hat. She greeted everyone with bubbly enthusiasm that matched the music she had composed. However, she still had to get ready. She quickly disappeared again into her trailer for wardrobe and makeup. It was not until 5 pm that she walked out of her trailer ready to begin the shoot. The crew helped her up on the jukebox and after a flurry filled day of action I began to shoot.

As now it was rather late in the day, Universal brought out their equipment to help light up the buildings so I could continue to shoot. There were several different set changes we still had to accomplish. Donna wanted to be photographed inside a convertible while changing the radio on the dashboard. She had also rented a huge limousine for another concept in which she would wear an evening gown and have a chauffeur.

The outdoor session went well despite all the challenges leading into it. My crew and I finished around 9 pm that night. However, as they were packing up I could not fight a nagging feeling that I was dissatisfied with the images that we had captured. Casablanca I knew spent a lot of money on props that day. But the amount of money one spends does not always translate into a powerful image. I did not feel we achieved an image that was impressive enough to be the next album cover for Donna Summer.

I pulled Donna aside and shared my thoughts with her. I offered her a continuation shoot the next day, free of charge, at my studio. To my delight, she agreed to arrive the next day around 11 am at my studio. Now the pressure was on me to come up with a real winner shot!

My crew and I went back to my studio and began preparing immediately for the next day's session. We were all exhausted. But in those days, I worked off adrenaline and creative passion which fueled me to

push past my normal physical limits. I spent the night conjuring up a new set from the depths of my imagination.

First thing the next morning I ordered another jukebox from a prop house. I asked my crew to come in early the next day. I had them cut an entire skyline of a city out of foam core which I drew by hand the night before, to be used for the background silhouette. There were no photo apps I could use to drop in backgrounds as there are today. If I wanted it, I had to find a way to create it in my sets myself.

I went to the fabric store and bought the biggest rhinestone sequins they sold. I had my assistants glue them to a large blue seamless back-drop to portray nighttime stars.

I used my 2 1/4 by 2 1/4 Hasselblad as that format translated best for album covers. I also had them lay a clear vinyl floor down to help create a fantasy vibe. The jukebox was delivered just in time as Donna arrived early this time to do her makeup.

Donna brought in a stack of vintage dresses and shoes. She never relied on others to tell her what to wear. She always had a keen sense of the image she wanted to project. The dress she selected that day was fabulous. It went perfectly with the jukebox against the surrealistic diamond studded background I had created. It was just the look I was after. What I shot the previous day was okay. But it was no comparison to what I was able to create with my signature studio portrait lighting!

I shot with film as digital photography did not come about for another 20 years or so. Shooting with film was very labor intensive. With high energy clients like Donna, it required me to keep an assistant on hand to reload my cameras so that I could keep up with her movements.

Every time I reflect on this shoot, I am so glad I offered to do this additional session with her for free. I derive a tremendous amount of satisfaction knowing that I trusted my hunches as an artist and believed in myself. Donna absolutely radiates in these photos I took with her in my studio. This cover has left lasting impressions on all who remember it then, and for the decades that have followed!

Album cover for "On the Radio."

Donna's Make-up trailer.

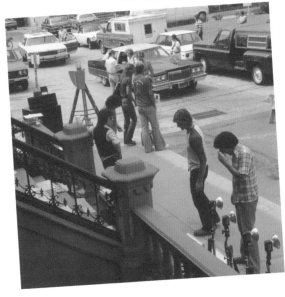

Donna posing with Classic Cars on street set.

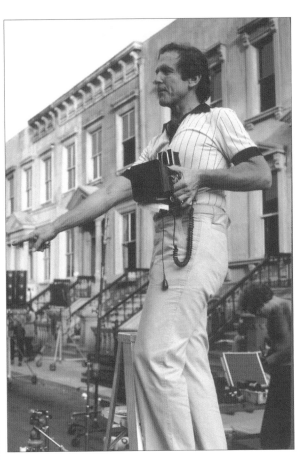

Me directing Donna on set.

Various crew members waiting on set.

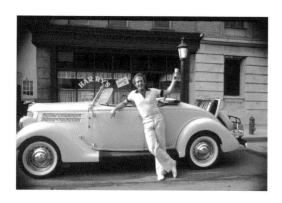

Me posing in front of the "Harry's ice cream" shop set.

My photo assistants loaded cameras during what was an extremely hot smoggy Day.

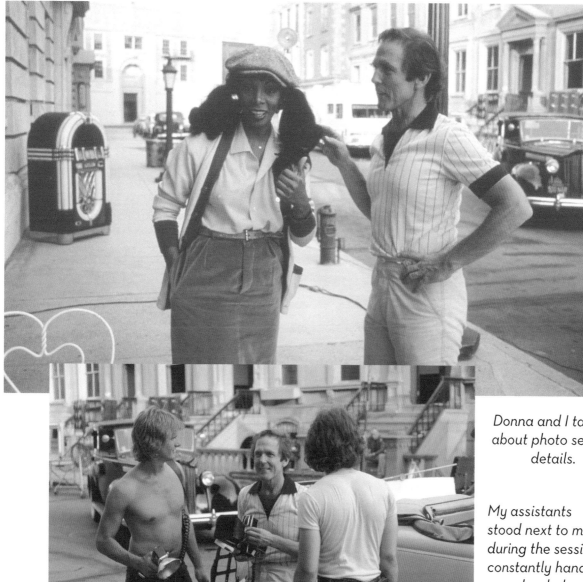

Donna and I talking about photo session details.

My assistants stood next to me during the session constantly handing me reloaded cameras to keep the session going.

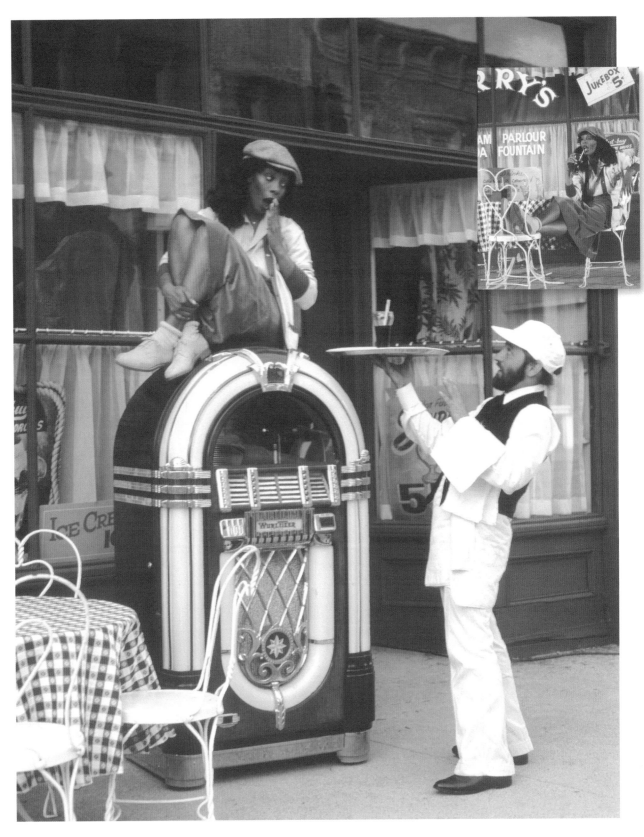

Donna on the outside jukebox set. This was the first "On the Radio" cover concept until I requested to do an additional session in my studio where I conceived the set/photo that was eventually used for the cover. Insert: Out take of Donna on ice cream shop set.

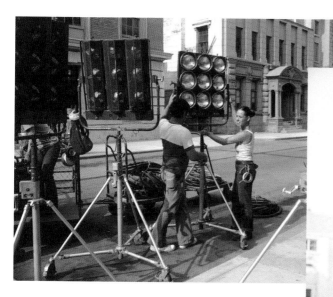

As the shadows of late afternoon began to fall on the buildings Universal Studios brought In additional lighting so that I could continue to shoot.

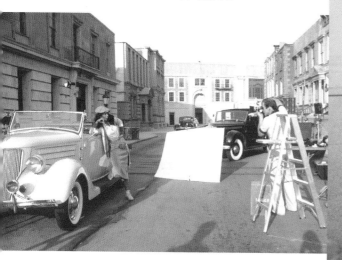

Donna and I in action mid-shoot.

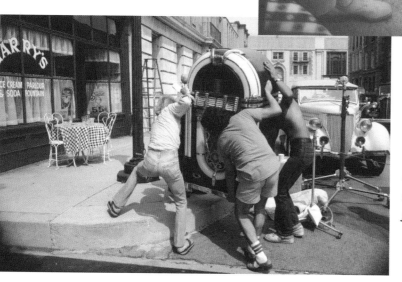

Donna and I goofing around on set.

My assistants moving the jukebox on set.

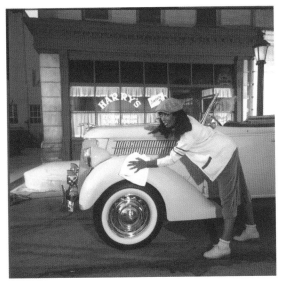
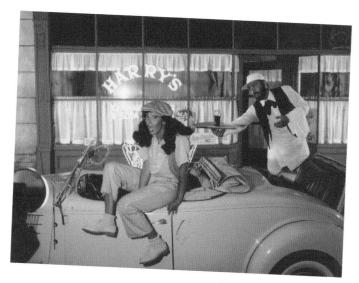
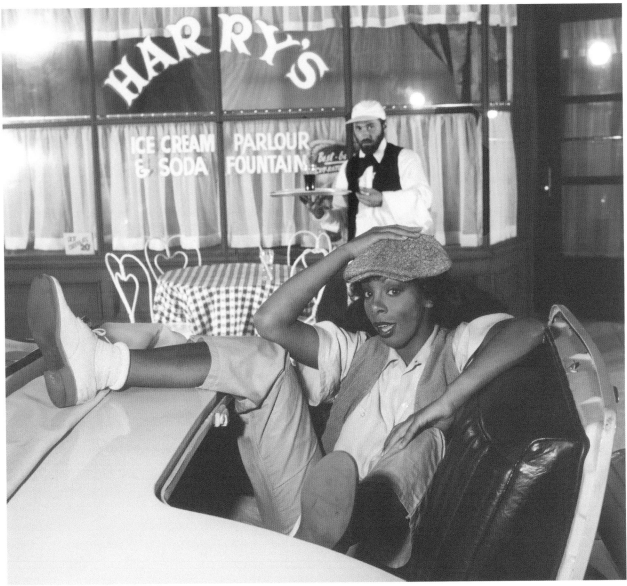

Various outtakes of Donna on ice cream shop set.

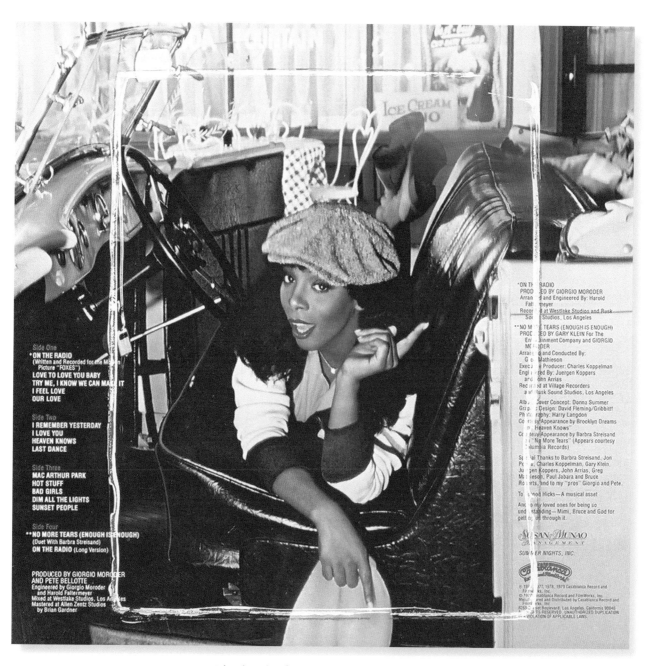

The back of"On the Radio" Album.

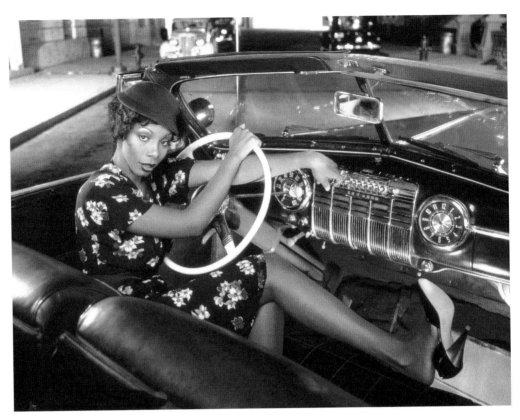

Nighttime session with Donna in the convertible rental car adjusting the Radio.

Donna on the Limousine set with evening dress and chauffeur.

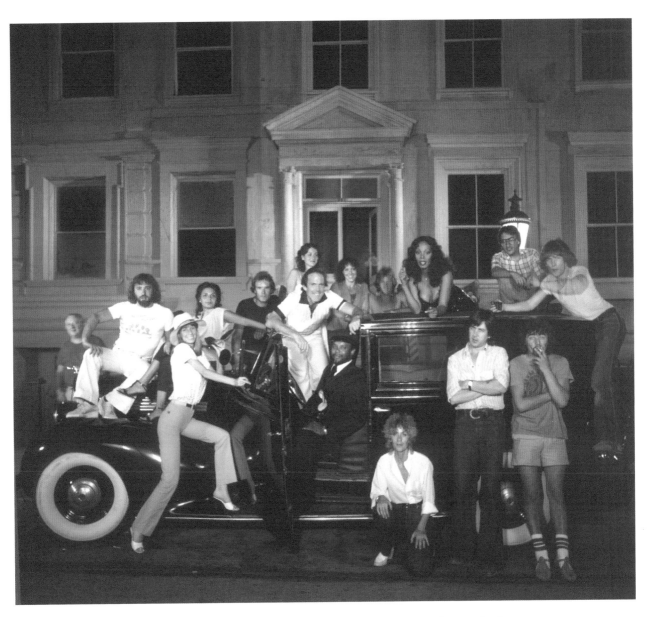

The whole cast and crew group shot for "On the Radio."

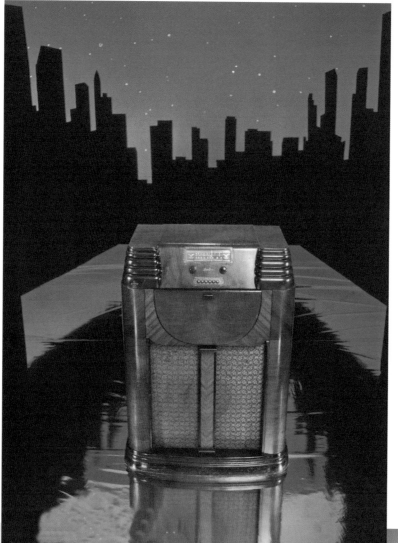

This was the 2nd day set I created which was selected for the cover. I used colored gels on the lights to give it a surreal vibe! I had to rent another jukebox for the day.

Me resting after a full night of set assembling and lighting..

My assistants rapidly cut out the city skyline from foam core.

I had them glue giant rhinestones to the paper background for stars.

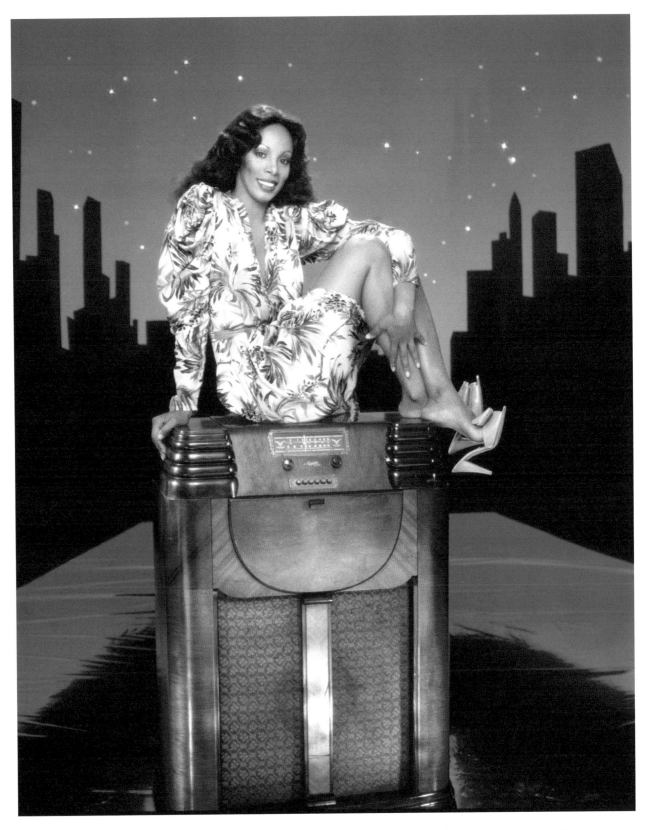

This was the final shot that was used for the cover of "On the Radio", note her blue shoes were changed to pink for the album (a detail her devoted fans pick up on). The rhinestones on the paper accomplished the effect I was after perfectly and shimmer like real stars!

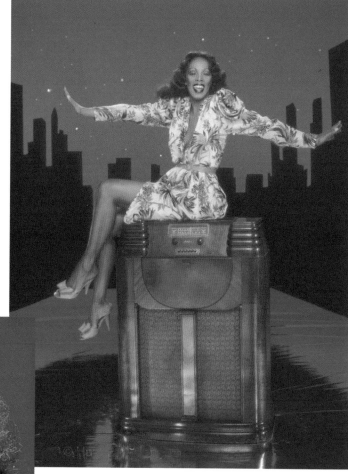

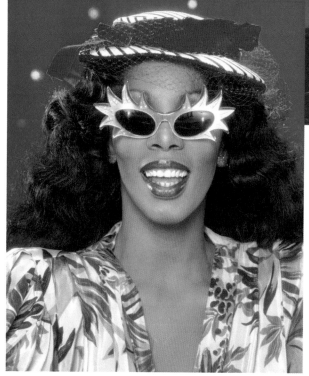

These are other fun outtakes taken during the session. All good photos, but only a few can make the album. Many of the outtakes went on to be used for publicity eventually in other articles.

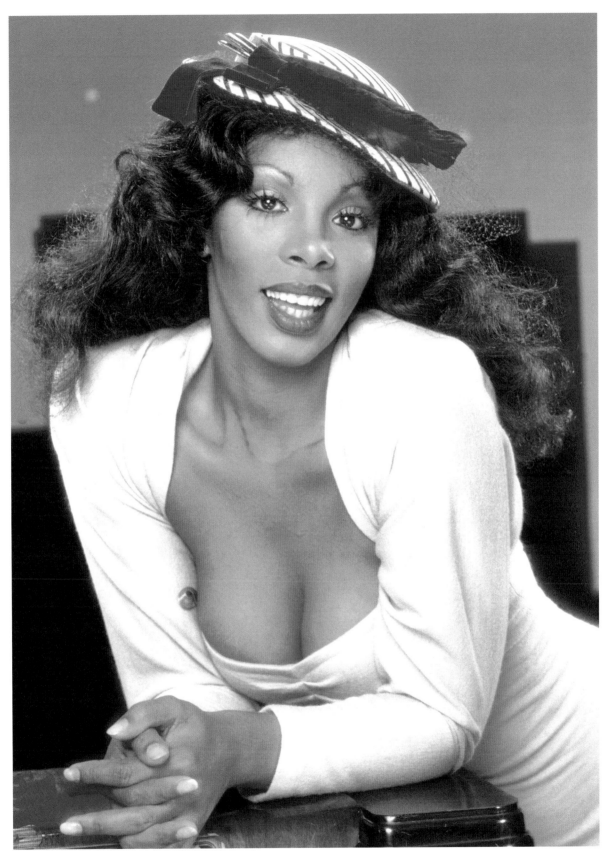

One of my favorites from the 2nd day session.

"THE WANDERER" ERA

The next time I was to hear from Donna a lot had changed. It was mid 1980 and while it had only been one year, she had made several major changes in her image and career. Donna had been growing frustrated with what she felt was Casablanca records continual portrayal of her in a sexual context. She wanted to go in a different direction with her music. So, she broke away from them to sign with the newly formed Geffen Records while keeping on Georgio Moroder and Pete Bellotte as her producers. This took a tremendous amount of guts and faith on her part as she was the first talent to sign with them.

By this time Donna and I had become close friends outside of just doing photo shoots. We both attended Fred Price's Christian Crenshaw Center services as did many other well know Hollywood individuals of the time. Mr. Price welcomed everyone and brought many people positive spiritual healing. On several Sundays I wound up sitting next to her. On one special occasion she asked me to accompany her into the healing line. While I was initially hesitant. I sensed it was important to her, and so she grabbed my hand, and we walked down to the front. Mr. Price put his hands on each of our foreheads and prayed, sending

us falling back into the arms of the attendants. It was a powerful and moving experience for the both of us. Afterward, I never asked her why she had wanted special healing prayers. But, looking back on this day, it never mattered to me to know. I was honored that she felt close enough to ask me to be there with her. This is the comfort level that had formed between us. One which helped establish a wonderful open space for creativity to flow.

Which is why when she called to book me for "The Wanderer" session the only direction, I was given was to rent a park bench. It was left totally up to me to tap into my intuition and create a set revolving around only a bench. While it initially seemed like a very simplistic and vague theme. I knew that Donna would come in prepared with a very clear vision of the character she wished to portray. All I could do was wait.

The day of the shoot arrived. Donna appeared at my door holding an old suitcase and a bag of thrift store clothes. It was only then that I realized she would be dressed as a drifter. While the past shoots had included lots of props and many characters. This one was drastically different. The challenge for me was how to take such a basic set and make it visually compelling enough to achieve the impact of a great album cover.

While Donna was in hair and makeup, I took to enhancing the set in the ways I had become famous for. I had my assistants lay down a vinyl

floor on top of a white seamless background. The shiny floor created a hint of fantasy to my photos. I then added purple gels to my fill lights to get a vibrant color and brought out my adjustable strobe light to give the background depth and ambience. To me "The Wanderer's" imagery was more than just this photo. It symbolized what I felt she may have been going through on a broader scale personally traveling and searching.

I'm often asked what my inspiration was for this album's photos, and why the rose is left on the ground. I tried to create a feeling that Donna was going off into the unknown. The rose symbolized a piece of her soul left behind. It is a metaphor for all of us and how we go through life. Which is why I believe such a simple set resonated so well with her fans. They could relate to her on this basic level of human nature. The quest we all have to keep searching for answers into an unknown future.

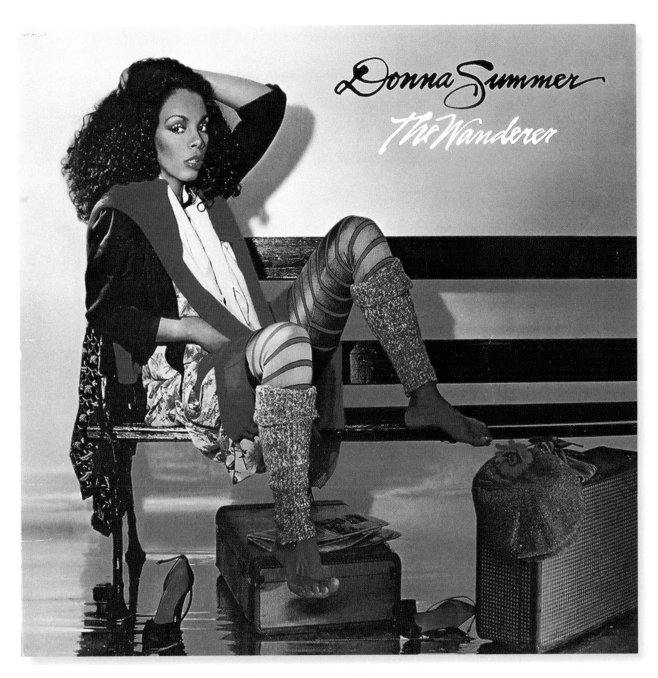

"The Wanderer" album cover.

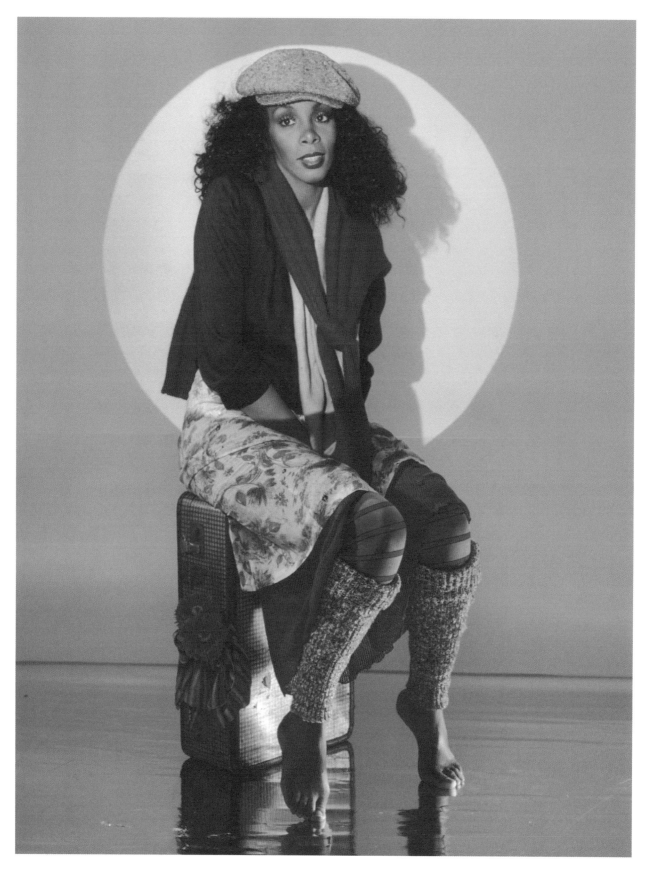

One of the many thrift store outfits that Donna brought in for the shoot.

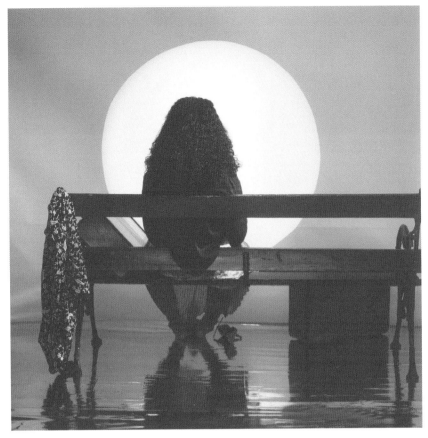

I had Donna turn with her back to the camera in a silhouette to create a bit of mystery as to where she metaphorically may be headed into her future . So much can be done using lighting to turn a simple set such as only a bench into a deeper message.

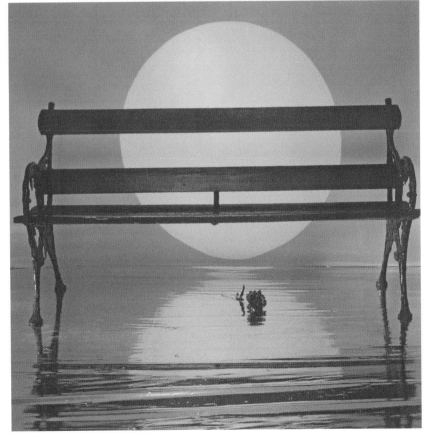

The rose left on the ground as I mentioned prior symbolizes a piece of her spirit left behind as she moves on. It is in my nature as an artist to use symbolic imagery as I put together my sets.

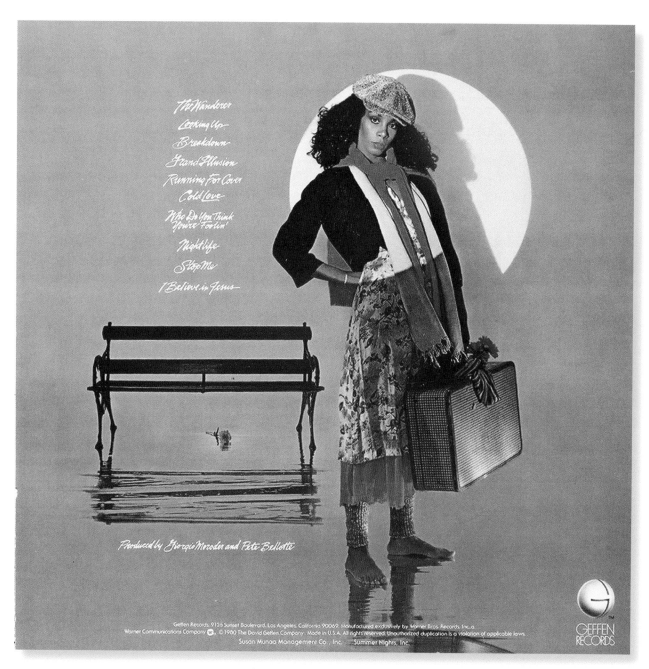

Back cover of "The Wanderer."

THE GODFATHER

Giorgio Moroder was one of Donna's producers. He is someone she trusted and kept on her team throughout. He has a deep history in the world of electronic music. He produced many disco classics and hit movie soundtracks for "Flashdance" and "Top Gun". He worked with all the top artists of the time and is often referred to as the "Godfather of Electronic Music."

Donna booked a photo session and requested I do some shots of him with a piano. He wanted publicity photos for an album he recently released with singer/songwriter Chris Bennett. So I rented a beautiful white piano to be delivered.

The day of his session was a very rainy day in Beverly Hills and the delivery truck was delayed. So, Mr. Moroder and I were left waiting. He had a thick accent, and it was hard for me to communicate with him. I did my best to keep him content until the piano arrived. Once the piano finally arrived, however, it had to be assembled. A rather big detail that I was not made aware of which kept us waiting even longer!

If unexpected surprises like this occurred on my photo shoots. The key I found was to remain calm. There is nothing that can be gained by getting upset or angry. It will only serve to ruin the energy for a good session.

In the end, the photos I captured of Mr. Moroder and Chris Bennett in front of the white piano are some of the best I have ever seen taken on him. He was a master of his craft and as such I wanted to denote a certain magical quality in his image. Which I accomplished beautifully by using one of my star filters!

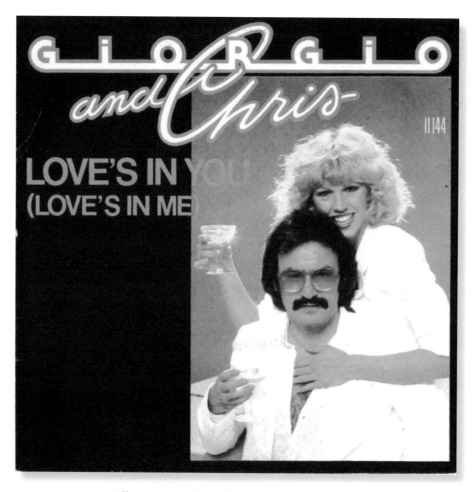

Album cover "Love's in You, Love's in Me."

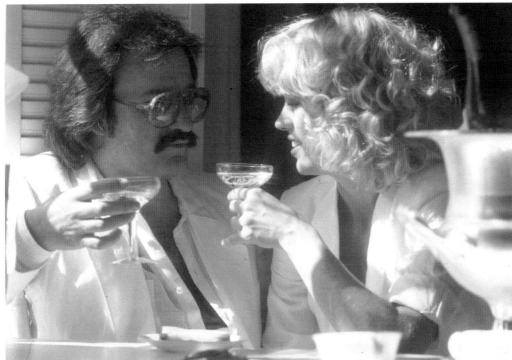

Top: A moment I captured between Giorgio and Chris as we waited for the piano to arrive.

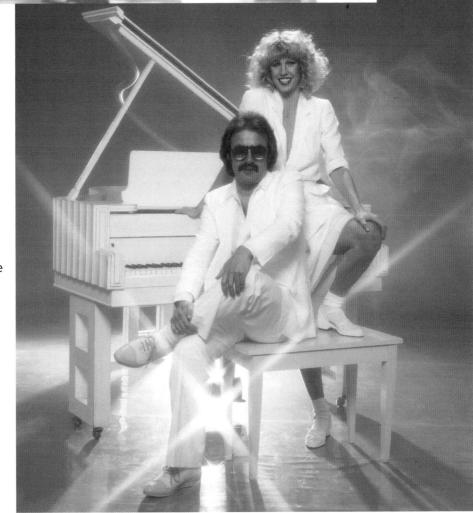

Bottom: Giorgio Moroder and Chris Bennett looking dynamic in front of the white piano featuring my star filter.

"I'M A RAINBOW"

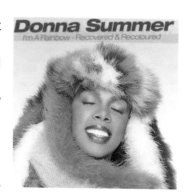

Every album cover I did for Donna was not always planned. As in this cover photo I did that was used for her "I'M A RAINBOW" album.

This was the product of a long day of creative and fun experimentation. Donna did not live too far away from my studio at the time. So, she would often book sessions with no particular reason other than to see what might be spontaneously captured.

I do not recall at the time that there was any special significance to this hat. I remember her throwing it on, and me thinking it was a cute shot and capturing it. I did not realize it would eventually become an album cover and end up being such a fan favorite. But what I do feel, is the fact that I captured her wearing the rainbow, which has gone on to become a symbol of pride for individuals today, seems perfectly fitting.

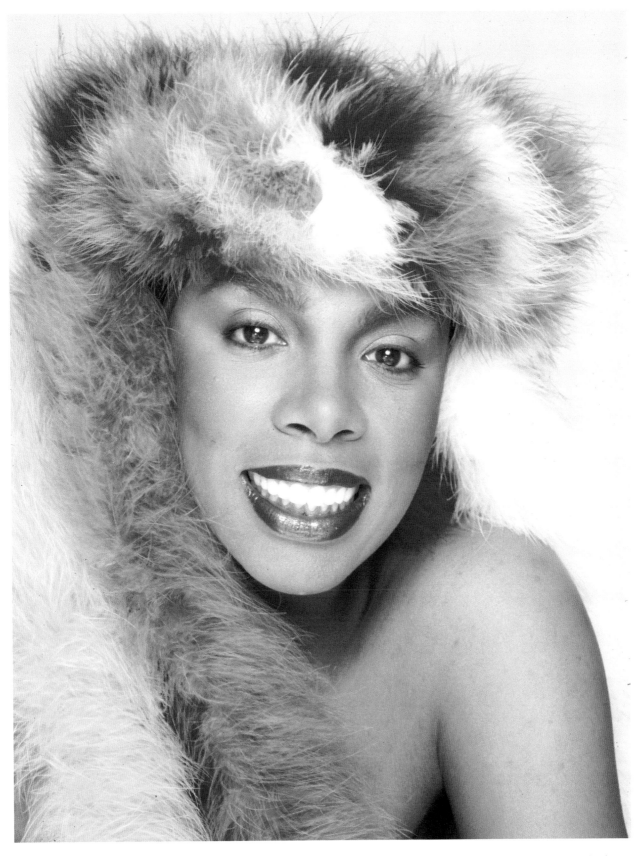

The rainbow photos I took of Donna are some of her fan's favorites. Her smile radiates with the burst of colors in the hat, and one can't help but feel her joy emanating though when they see it!

INSPIRATION STRIKES
"She Works Hard for the Money"

It was September of 1983, Donna and I had done several experimental sessions in my studio. She was stuggling to get inspiration for her next album's theme. As usual Donna always had a great selection of clothes and hats to test with. I got a lot of wonderful pictures of her, but she was still searching for a concept she was passionate about. After one of these sessions, we wrapped up for the day. Coincidentally, we both had been invited to evening parties at the same place. Chasen's was a popular restaurant at the time and my client Julio Iglesias had invited me to his birthday party there. While Donna and her manager Susan Munao attended the Grammy Celebration being held there.

Everyone was mixing around the room talking and drinking. The guests of each party had blended and were familiar with each other. Donna and Susan took a break and left for the ladies' room while I went on chatting. The next thing I knew Donna and Susan came running up to me filled with excitement exclaiming, "We have the title of Donna's next song!" It took a while for me to calm them down and figure out what it was all about. But once I did, the two shared with me that upon entering

the ladies' room Donna saw the attendant inside, and thought to herself, "She Works Hard for the Money!" And, just like that, a new inspirational Donna Summer hit was born!

I have seen a lot in my years working with such a wide variety of talented and successful people. However, this story is one I never get tired of sharing. It was such a wonderful experience to be with her that night. To witness her take something so simple that others walk right past and go on to make it into such a powerful, generational statement was nothing short of creative genius!

Our next photo session together was scheduled shortly after that night. It was to be another two day shoot. The first was in my studio. By this time, I had been working with Donna for many years. I had done several of her album covers. Each time as an artist I was compelled to top myself. I knew Donna wanted a diner theme. So, I chose to use electric yellow as the background color. I knew against her pink diner waitress outfit the colors would complement each other and pop. I also knew that Donna was a powerful woman, and in selecting this color I was making a subliminal statement. Other individuals may have been overshadowed by such a bold color choice. But the bright yellow only served to enhance Donna's dynamic charisma.

To achieve a diner aesthetic, I went to the local auto store and purchased a few roles of striping tape. My assistant and I made a 4 by 8 ft

rectangular frame and stretched the red tape at an angle between the frame's sides. When placed in front of the yellow paper it gave the effect of diner walls. For my main lighting, I used a ring light. It is a trendy light source that when used correctly gives the pictures a unique edge.

For the second day of shooting, Donna asked me to rent a diner in Century City called AHS. This day was a more fun, improvisational day that included the cast and crew. One detail many may not be aware of is that Donna insisted that Onetta Johnson, who was the real ladies room attendant at Chasen's be included. She had a matching waitress outfit made for her to wear. A photo of the two of them was used on the back of the cover. A sweet gesture to the woman who had inspired her hit song. It was a top Billboard song of 1983, and she won another Grammy in 1984 for "He's a Rebel".

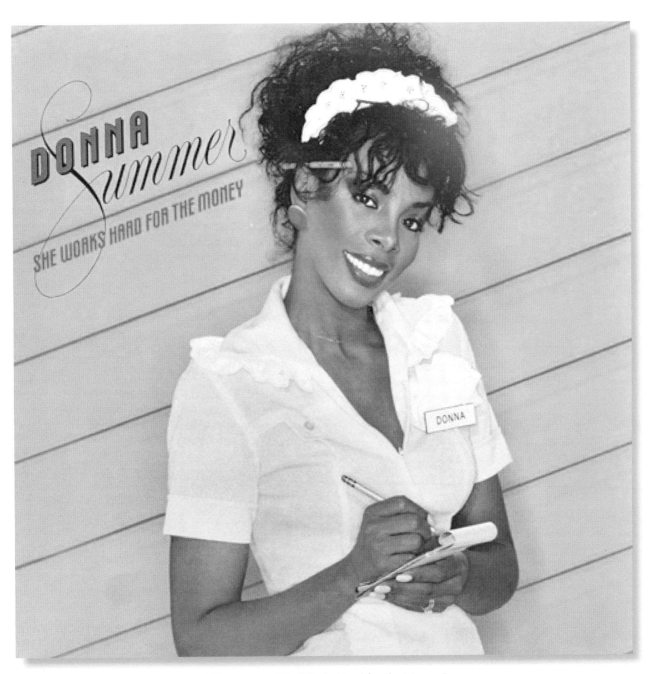

Album cover "She Works Hard for the Money."

Several great outtakes from the studio session for "She Works Hard for the Money."

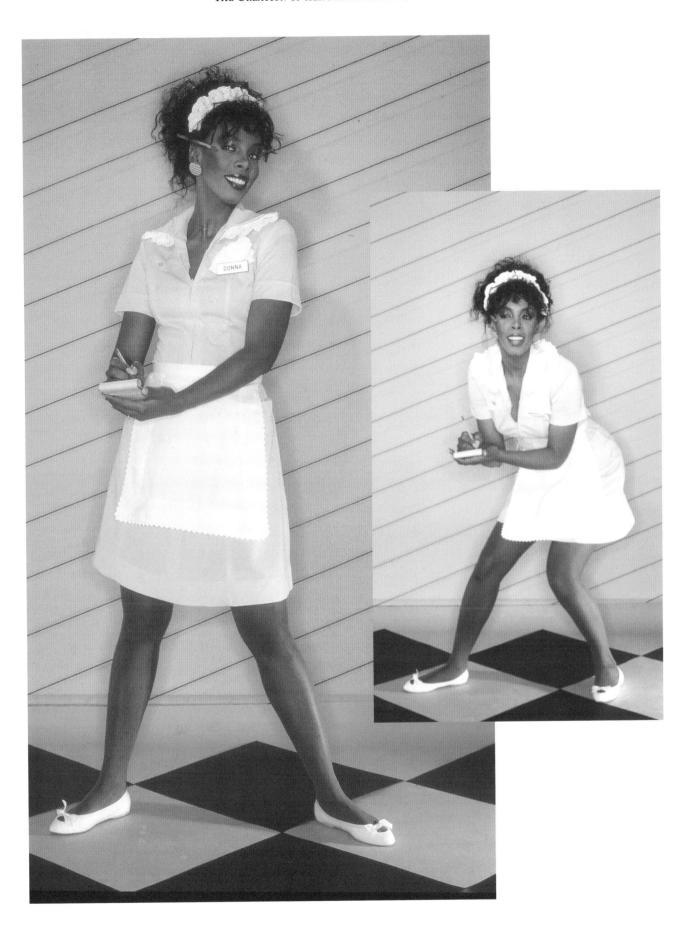

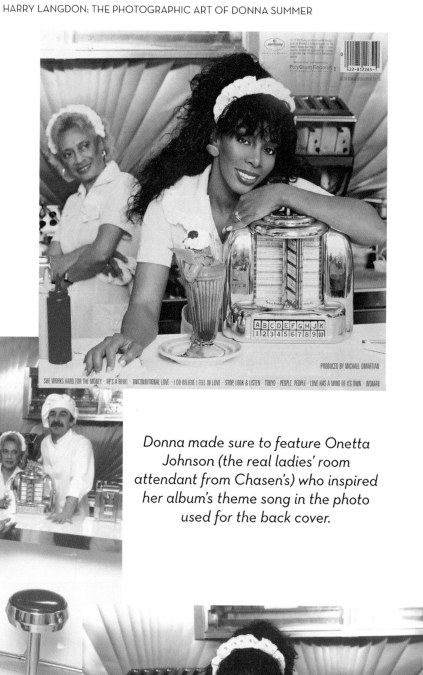

Donna made sure to feature Onetta Johnson (the real ladies' room attendant from Chasen's) who inspired her album's theme song in the photo used for the back cover.

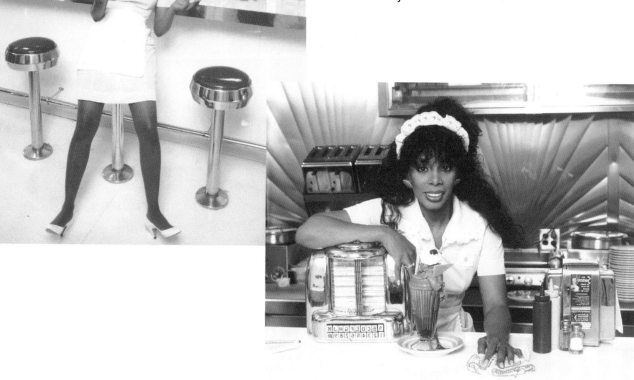

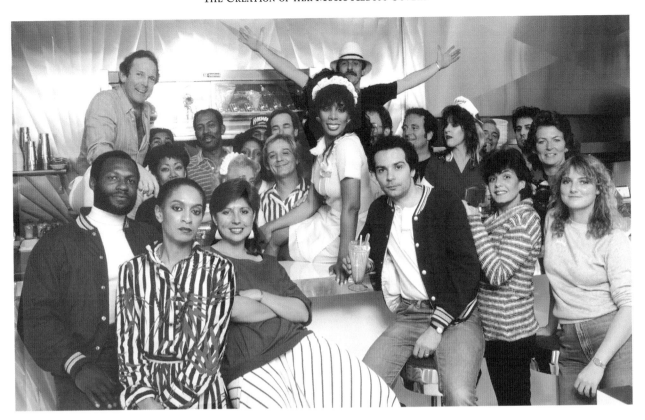

Group shot of "She Works Hard for the Money" cast and crew.

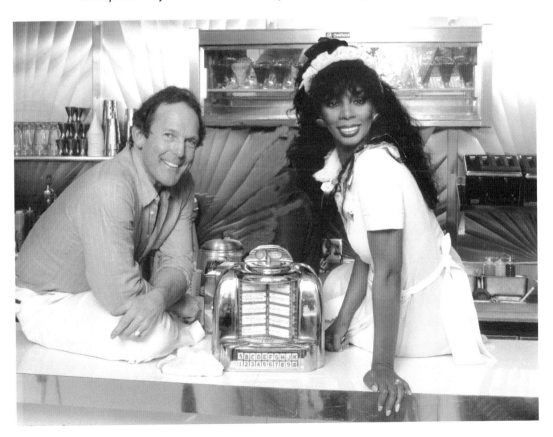

Donna and I taking a "Martini Shot" to commemorate the end of another successful shoot.

HIDDEN MESSAGES
"Cats Without Claws"

By this time in Donna's career her music began to be filled with spiritual messages. She was openly sharing her faith with her fans. She made sure that everyone she worked with had a similar calling. Her husband Bruce Sudano, and Michael Omartian were essential members of her team.

The session I did for "Cats Without Claws" was one of the shortest sessions we ever did together. We played around using different backgrounds and props. But the whole session only lasted around two hours. Donna and I had worked together for so long that we were very synchronized and not a lot of conversation was necessary.

I have found that initially when a person is starting out, they come into the photo session by themselves. Then, as they rise to fame, they acquire a rather large entourage. But, oddly enough, the more famous they become they usually revert back to wanting to come in on their own again. They see the value in less is more and they seek to regain more privacy and control.

For those curious to know about the technical details. I went back to using my strobe lights, and I used my Hasselblad EL (2 1/4 by 2 1/4) as I noted earlier that the square format was best suited for 12 "album covers.

One of the hit singles from this album was "Supernatural Love". Back then, when a single was released, it would often get its own cover. So many of the photos I took during these sessions may not have been right for an album cover but might be used later for a single. While this album did not climb as high as "She Works Hard for the Money". It was clear that her spiritually imbedded messages in her lyrics were making a positive impact on her audience and this made her extremely happy. She won another Grammy for "Best Inspirational Performance" for her song "Forgive Me in 1985.

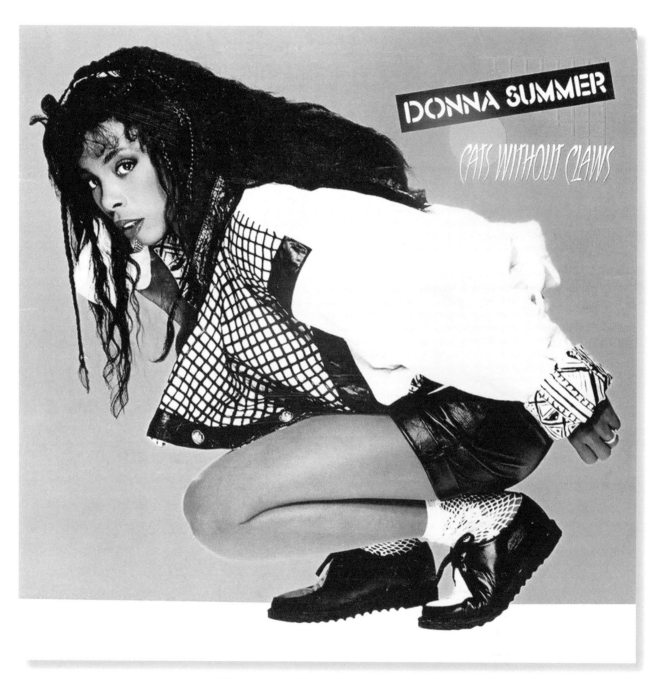

Album cover "Cats Without Claws."

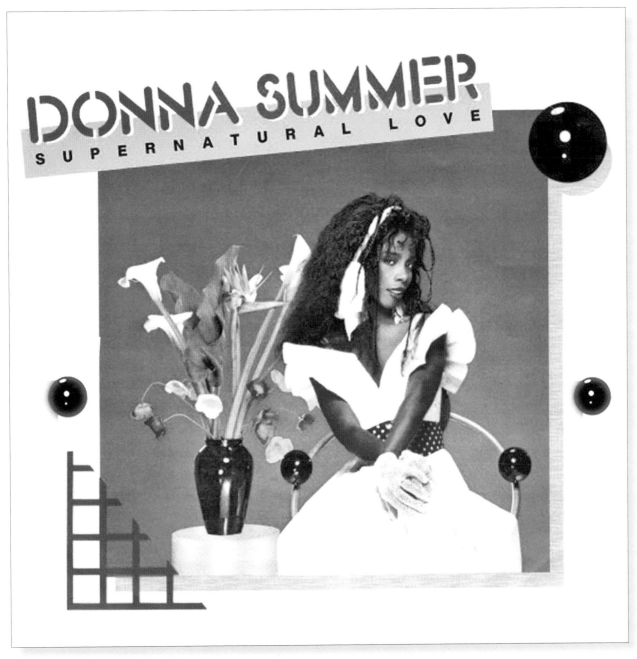

Single cover "Supernatural Love."

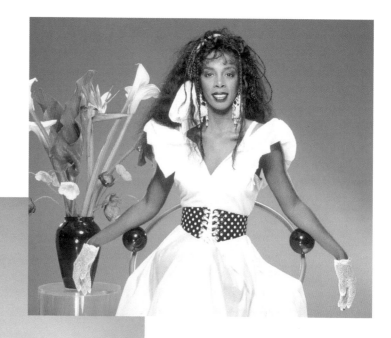

Donna was never short of creative ideas and had fun experimenting with a variety of looks!

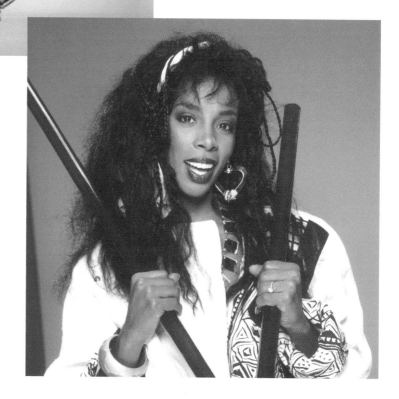

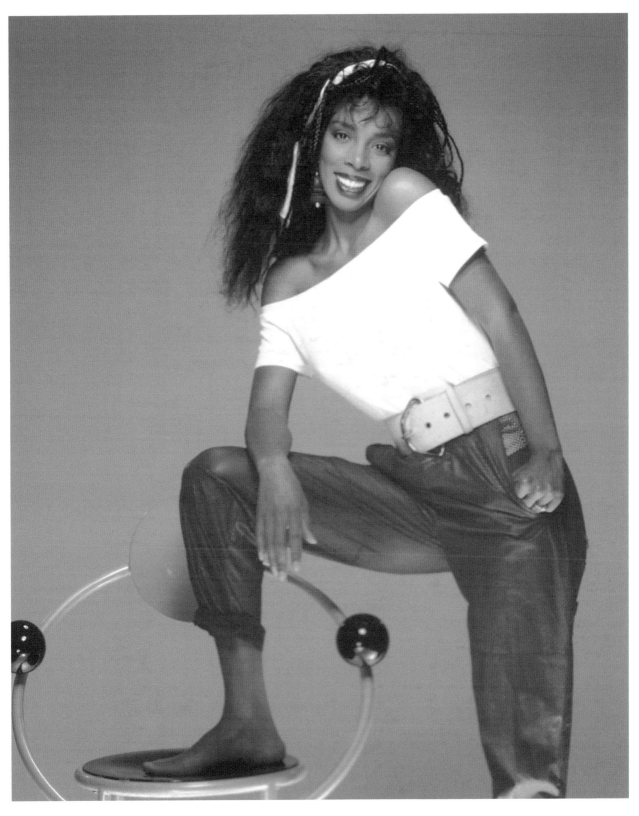

Donna had a kind, uninhibited spirit.

WORDS OF WISDOM

There are few clients that I worked with as long as I did with Donna Summer. She came to me in the beginning of her fame which also coincided with the beginning of mine. We evolved together in our work spiritually and creatively over the years, which gives these photos special resonance.

Much of my career I have been so busy looking forward that it has left me very little time to reflect. However, recalling these shoots and moments with Donna for this book has cemented for me the tremendous responsibility I have always felt to do what I do.

Donna Summer unfortunately is no longer with us. Many of my clients have passed on. But, knowing I was able to capture the beauty and magic of their souls on film to live on for the future. This is what drives me and fills me with joy.

To me everyone is a star. They just need to feel it and believe it. People worry too much about being perfect. When real beauty is imperfect. Many of my best photographs come from catching moments of imperfection. Yes, some individuals may get a world platform to share from. But no matter what you are given or not given please remember to shine and share your magic with the world as Donna always did!

Love Always,

Harry Langdon

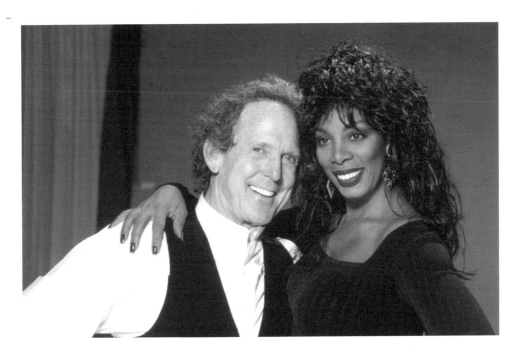

One of the last photos taken of Donna and I together.

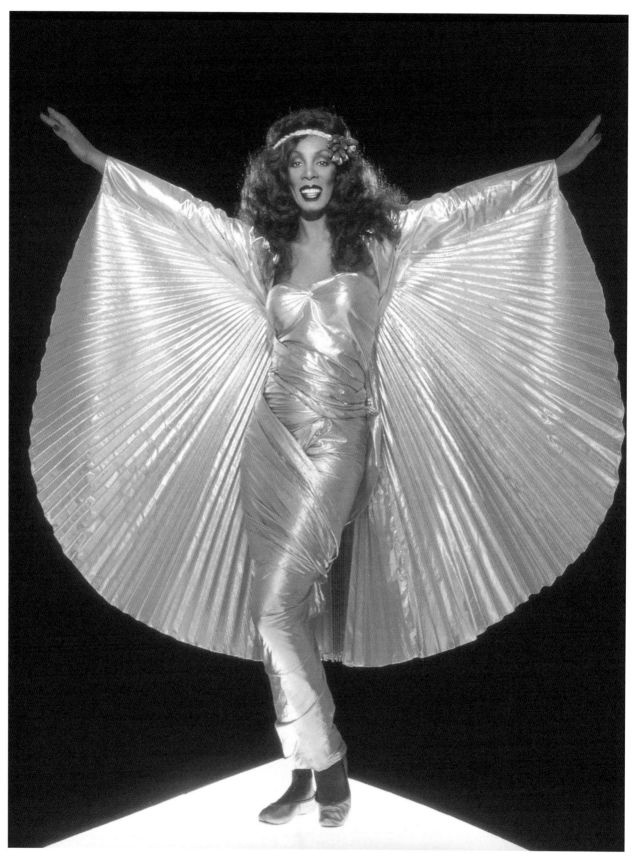

Donna looking every bit the Queen of Disco in this Erte inspired image and gold Lame gown.

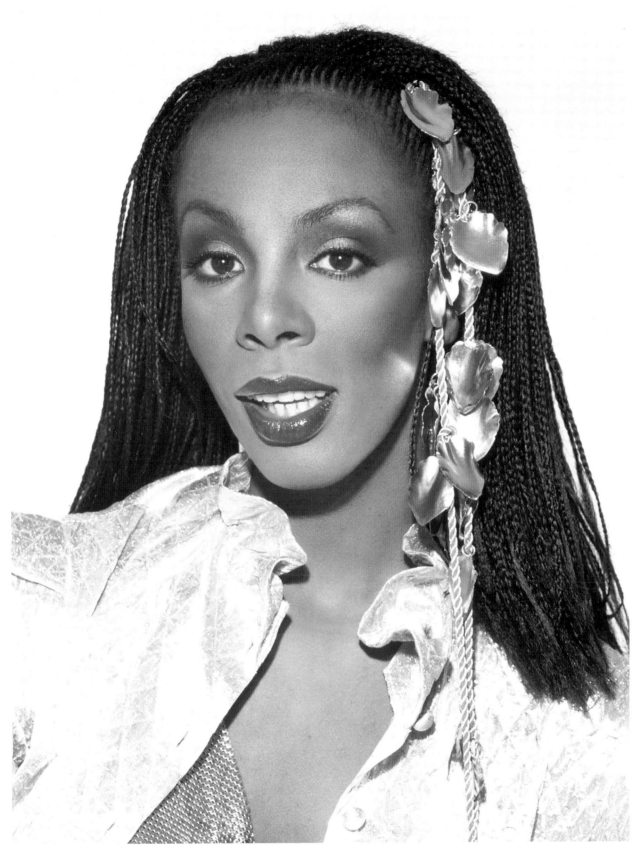

Donna omitting a Cleopatra vibe.

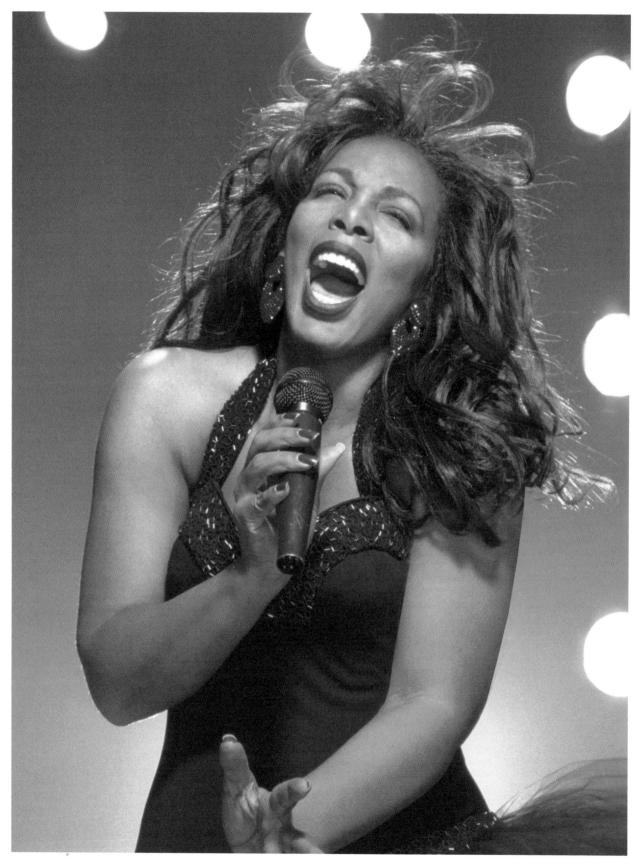

Capturing the passion that Donna had for her art was always an honor for me!

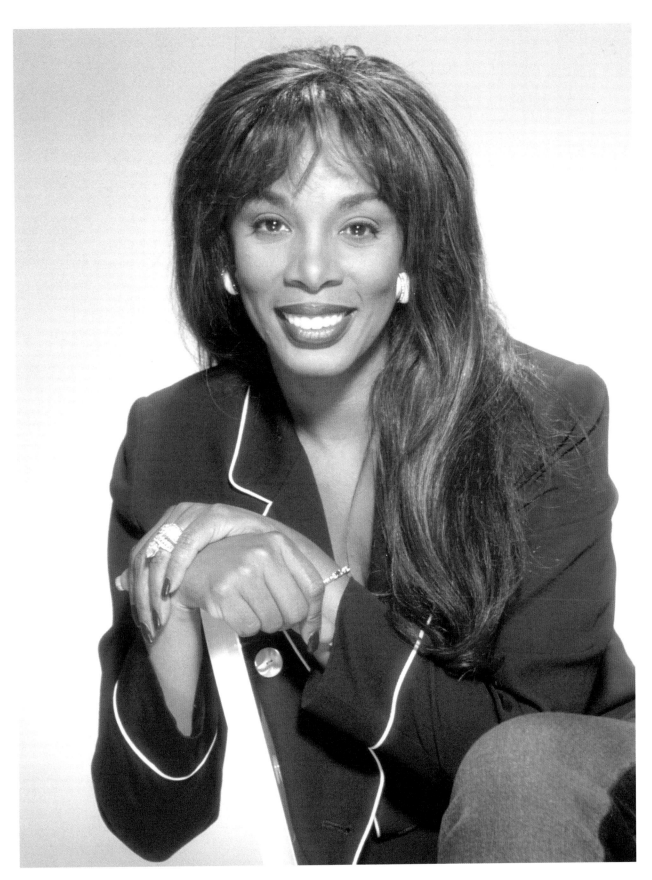

Donna in a rarely seen off stage casual moment.

Printed in Great Britain
by Amazon

46718490R00048